Sumi-e

SUMI-E

An Introduction to Ink Painting

by Nanae Momiyama

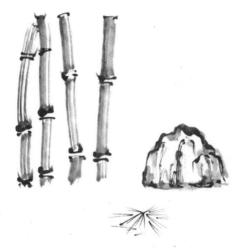

CHARLES E. TUTTLE COMPANY
Rutland, Vermont & Tokyo, Japan

Representatives

Continental Europe: BOXERBOOKS, INC., *Zurich*
British Isles: PRENTICE-HALL INTERNATIONAL, INC., *London*
Australasia: PAUL FLESCH & CO., PTY. LTD., *Melbourne*
Canada: M. G. HURTIG LTD., *Edmonton*

Published by the Charles E. Tuttle Company, Inc.
of Rutland, Vermont & Tokyo, Japan
with editorial offices at
Suido 1-chome, 2-6, Bunkyo-ku, Tokyo, Japan

Copyright in Japan, 1967 by Charles E. Tuttle Co., Inc.

Library of Congress Catalog Card No. 67-15320

International Standard Book No. 0-8048-0554-7

First printing, 1967
Sixth printing, 1972

Publisher's Foreword

The last decade has seen an enormous growth in the popularity of things Japanese: Architects have enjoyed the use of the beautiful simplicity of shoji in their designs; homeowners have sought the help of landscape artists who could create the peaceful atmosphere of a Japanese rock garden; teenagers and adults have taken to the miniature radios, TV's, and cameras; and—more recently—the whole world has looked to Japan for guidance in haiku poetry, art—particularly woodblock printing, religious philosophy—particularly Zen, and the martial arts—particularly karate.

The cry for more informative and educative material on these and other subjects has been answered by a large number of books and articles in various periodicals along with the outputs of the other media.

This book is to introduce the reader to *sumi-e,* the delicate prints made from a water soluable charcoal ink. While sumi-e is not as popular with the West as is the Japanese woodblock print, it has been slowly gaining appreciative audiences with the tens

of thousands who yearly are greeted by the majestic Mt. Fuji. More and more samples of the art have been taken back home by these visitors, who find charm in its simplicity and equate it with the serenity of the Japanese way of life. Sumi-e, however, originated in China, and was the art of Zen priests, by whom it was introduced into and practiced in Japan.

Sumi-e was originally published by the Japan Society of New York, a group with the purpose of bringing "the peoples of the United States and Japan closer together in their appreciation and understanding of each other and each other's way of life." Our cooperation with the Society which enables us to give this work a wider circulation is another step toward fulfilling our goal of providing "Books to Span the East and West" to the English-speaking world.

SUMI-E

Sumi-e, or ink and brush painting, must be discussed in terms of the religion and philosophy it expresses. Originating in China, sumi-e was the art of Zen priests, by whom it was introduced into and practiced in Japan. Sumi-e is thus an expression of Zen Buddhism, a religion of extreme self-discipline, concentration, detachment, and contemplation.

Because the importance of philosophy and religion is often ignored, interest in this oriental art is to a degree the result of a misunderstanding, and the result is merely superficial imitation. To appreciate and understand the art more fully one must first endeavor to look at the world through another set of eyes.

In the Orient the conception of man and nature is different from that of the West. Nature is animated and spirited, and man is a part of nature. There are no boundaries between the kingdoms of the plant, the animal, man, between the animate and the inanimate, the living and the dead. In direct contrast, the West distinguishes, classifies, and ranks almost

every conceivable object; to man it accords the most highly privileged position and regards nature as a thing created for his welfare. To the East such classification is irrelevant. What matters is the harmony of the universe, of which man is another member, endowed with no special rank or distinction.

The painter therefore becomes one with nature. To achieve this state the Zen priest practices severe self-discipline and concentration. He forsakes earthly frailties, such as anger, hatred, and worry. He further casts from himself his intellect and personality until ultimately his own self is cast away. By losing his individuality he becomes a part of nature. Attuned to nature in this manner, he gains insight into his own being and paints instinctively.

It is important to point out that in China and Japan the brush is normally used for writing. Painting is therefore an extension of writing. And just as in the West a man's character is revealed in his handwriting, so in China and Japan a man's character is revealed in his brush strokes and lines. An artist is therefore judged on qualities other than technical skill and facility. The power of the brush itself may be almost magical. One must handle it with a sense of gladness and thankfulness. In thus befriending the brush, it in turn becomes one's intimate friend; it will then respond to the painter's most sensitive feeling and become alive in his hand.

The artist may draw realistically or abstractly; however, the characteristic of the sumi-e artist has been to eliminate all inessentials and to represent

only the most expressive or important feature of each element of the matter. Consequently, details, perspective, and colors are usually omitted.

The Japan Society is an association of Americans and Japanese who desire to help bring the peoples of the United States and Japan closer together in their appreciation and understanding of each other and each other's way of life. It functions as a private, nonprofit, nonpolitical organization interested in serving as a medium through which both peoples can learn from the experiences and accomplishments of the other.

Inquiries should be addressed to the Executive Director, Japan Society, Inc., 250 Park Avenue, New York, N.Y. 10017.

The Tools of Sumi-e

Brushes
 The long haired pointed brush is for calligraphy
 and fine lines. The wide brush is for painting bam-
 boo sections and for large areas.

Sumi, or ink stick
 There are three types of sumi, distinguished by
 their tint, brownish, blueish, and gray. The method
 of manufacturing sumi is interesting. Lamp black
 is hand pounded thousands of times into minute
 particles, then formed into sticks with fine glue.
 Good sumi is labelled by the number of poundings
 it received, the more the better.

Suzuri, or ink stone
 The suzuri is a slab of stone with a depression for
 water at one end, on which the sumi is rubbed to
 prepare the thick ink. Good suzuri are hard and
 last indefinitely, while the softer types readily ab-
 sorb water and are less durable.

Môsen
 This is a blanket-like or felt material on which

paper is placed when painting. A desirable type should be white, thick, dense, soft, and short haired.

Paper

There are different types of paper in Japan, such as Gasenshi, Torinoko, Hôshô. Gasenshi is perhaps the best for sumi-e.

Color

Although sumi-e is essentially black and white painting, very subtle transparent pastel colors are often used. These colors are available in powdered form or in hard sticks like ordinary sumi.

Name or signature stamp

In China and Japan a stamp or seal has been used for centuries to represent or authenticate a signature. The design is personal and may be anything that pleases the individual. Japanese stamp pads are red but other colors may be used.

Applying ink to the brush

Wet the brush thoroughly in water. To begin painting, remove excess water by stroking it off the edge of a plate or on a clean piece of paper. Apply ink on one third to one half of the brush and only on the outside. Do this by carefully laying the brush on the suzuri and not by dipping it into sumi. Always be careful to keep the tip sharp and symmetrical and wash the brush often. Clean brushes by washing in water without soap, taking care not to damage the tip. Stroke away excess water and point the bristles to dry.

There are three types of line in writing and painting. The first figure below is *kaisho*. The lines in this style are straight, hard, and angular and show great strength. The second is *gyôsho*. The stroke in this style is soft, rounded, and rather free and shows less strength. The bottom is *sôsho,* in which the lines are extremely free and flowing. The three are, of course, the same word, or character.

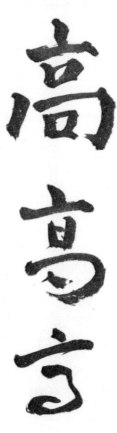

This character, pronounced "ei" in Japanese and meaning "long," contains the eight different basic strokes necessary to write all the characters. As these strokes are similar to those used in painting they are quite important.

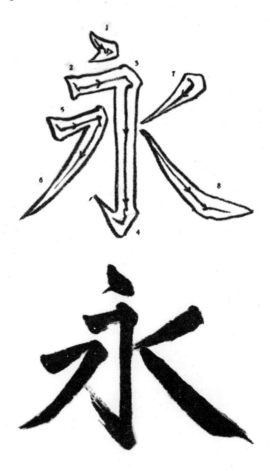

These are primary strokes for drawing a bamboo leaf.

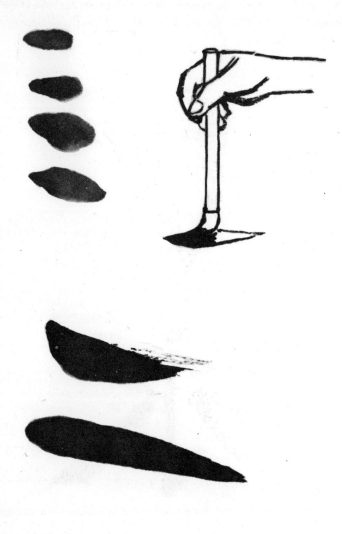

This exercise in spirals and lines should be practiced very slowly. Its purpose is to steady the hand and nerve and to prepare one physically and mentally for painting.

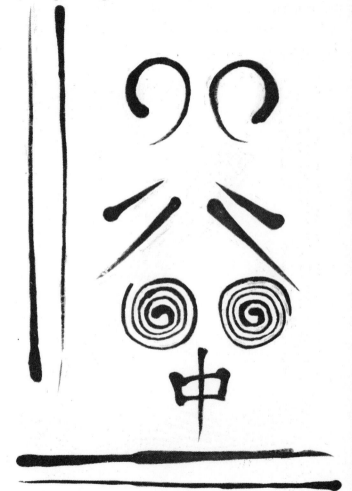

Concentrate and draw very thin lines carefully. When drawing short, sharp lines with the right hand, support the right wrist on the back of the left hand. Long tapered lines should be drawn freehand. Hold the brush near the top (see p. 14), keep the elbow free, and draw with the whole arm.

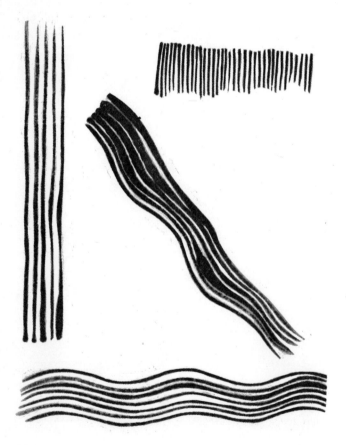

The contrast of thin with thick lines is interesting and worth careful study. Thin lines may look like fish bones, nails, waves, small bamboo sections, or pine leaves. Since the brush is soft and flexible, one can change form readily.

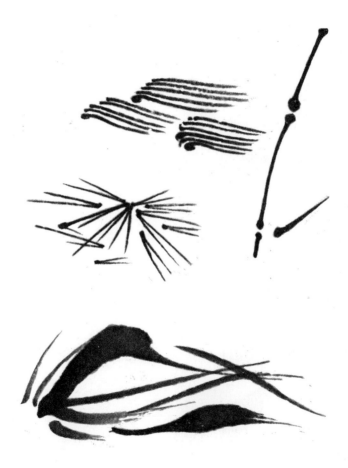

Dots and combinations of dots.

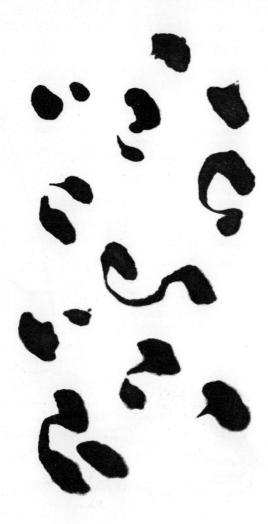

Different shapes of bamboo leaves, simple, short, long. With these strokes one may draw a fish, an eel, a leaf.

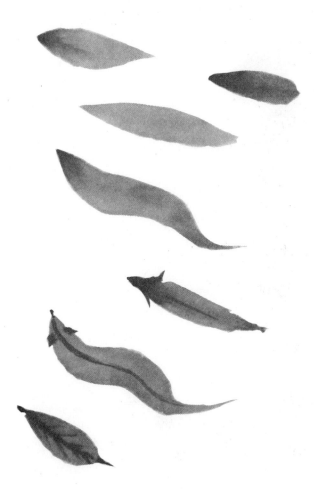

There are many types of bamboo, and it is best if possible to study from an actual section. Bamboo is one of several plants, including the plum in blossom,

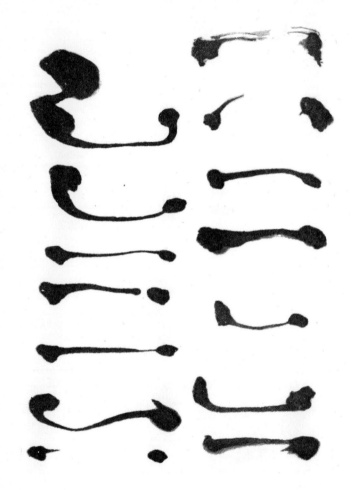

the pine, chrysanthemum, and orchid, which have
been the object of special appreciation in China and
Japan.

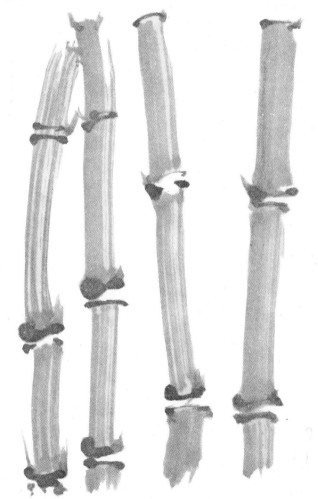

Composition of two bamboo leaves and stem. The left leaf is painted first and is smaller and darker than the other. The stem is painted with a smaller brush. The contrast between the broad leaves and the sharp thin line of the stem is interesting.

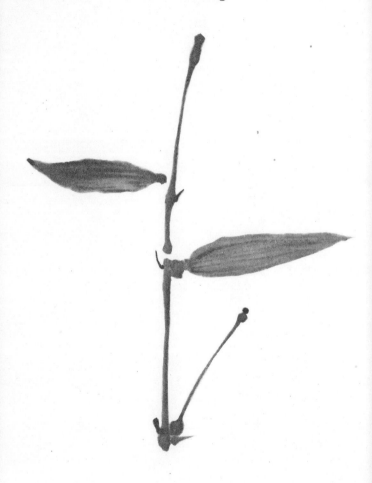

Brush strokes for orchid leaves.

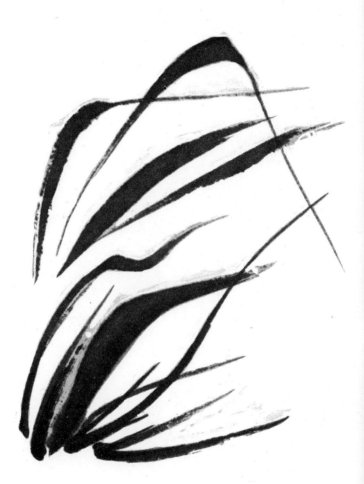

There are two distinct styles of sumi painting. The most common is the one illustrated at the right. The other is the *hakubyô* style, in which only the outline

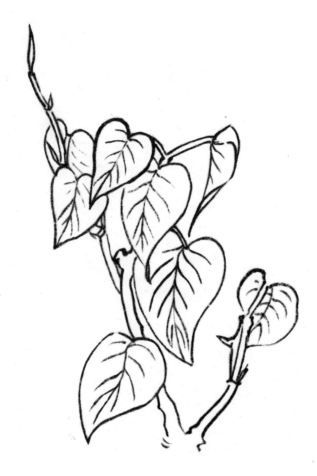

and important lines are drawn with special small brushes. This style is not much followed in Japan but is quite common in China.

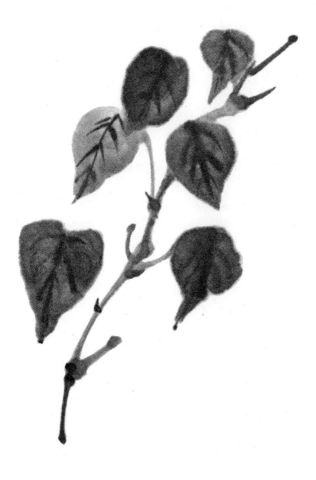

Plum tree branch and branch of young bamboo.

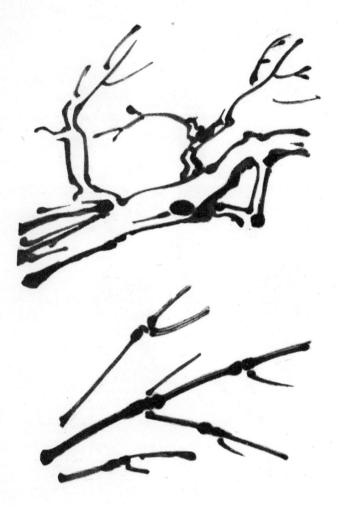

Practice strokes for twigs.

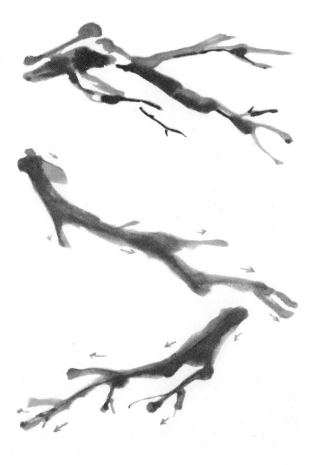

Study of rocks.

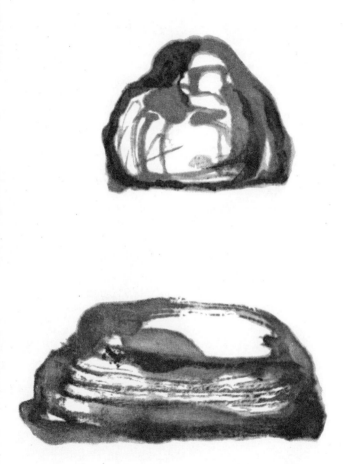

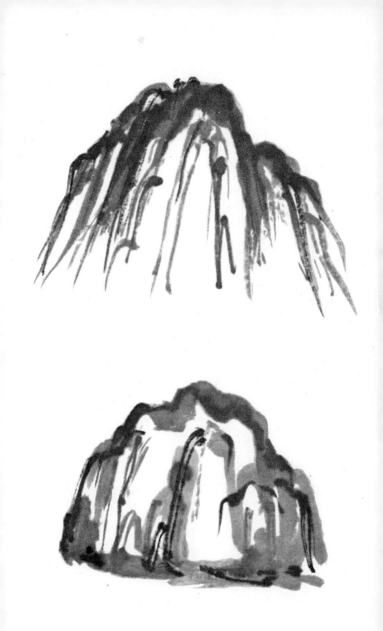

Further strokes for bamboo leaves.

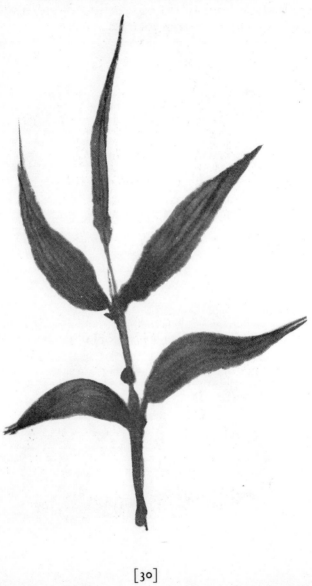

Wet brush throughly and stroke off excess water. Apply dark sumi to tip of brush to paint pistil and stamens, which are represented by dots.

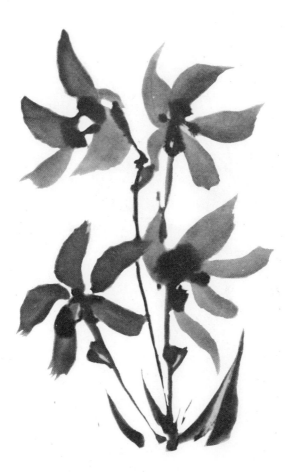

Here and on the following pages are illustrated some combinations of various strokes to form pictures.

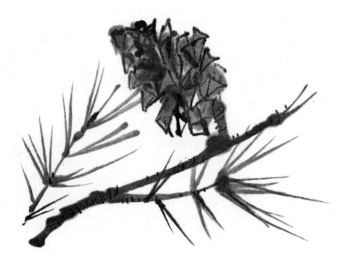

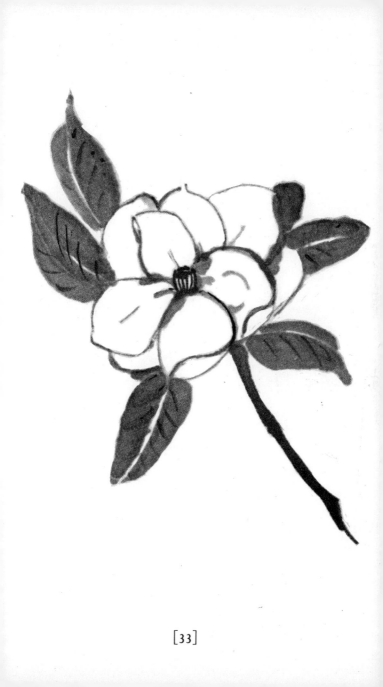

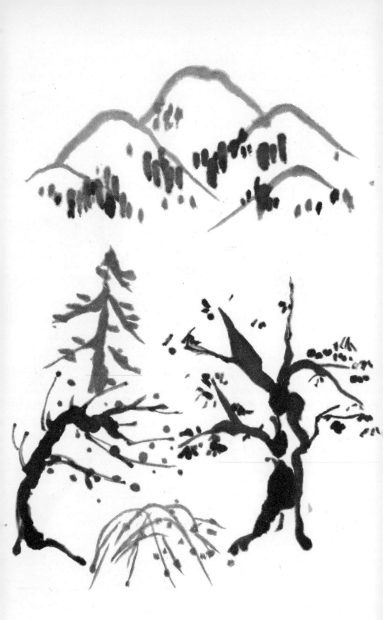

[34]

From basic strokes and combinations you may move on to a complete picture. First visualize the whole of what you wish to do. Next think in terms of composition, light and dark areas, main accent lines. You may start either from the lightest area and work to the darkest, or you may work in the opposite way from the darkest area.

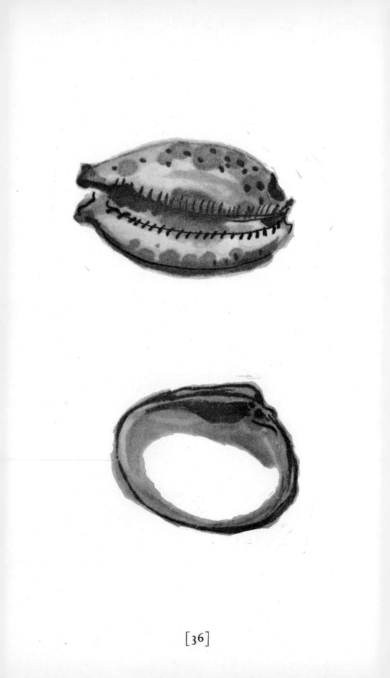

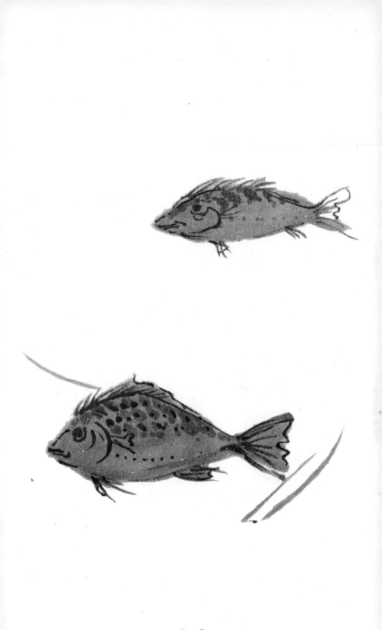

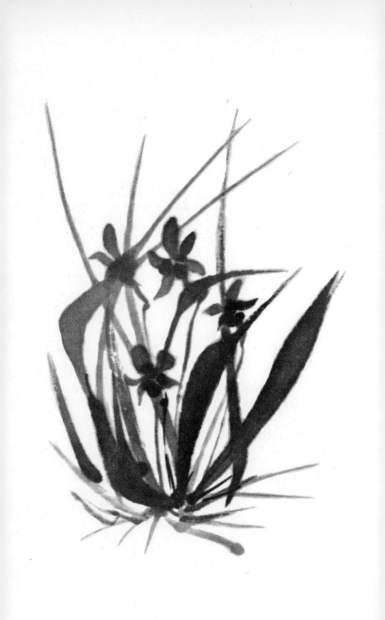

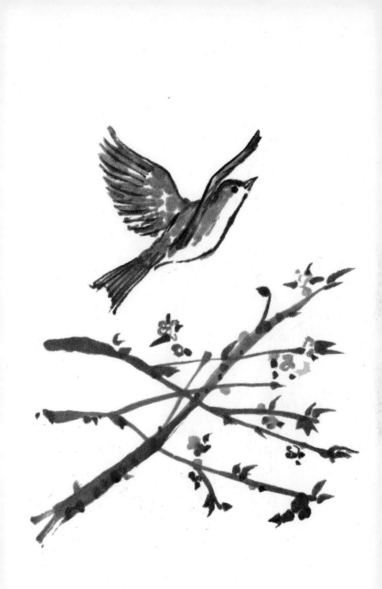

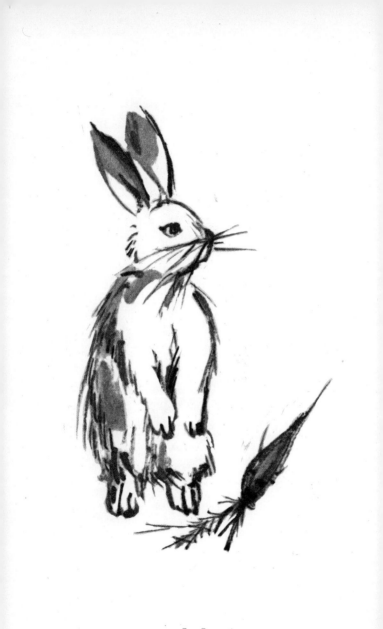

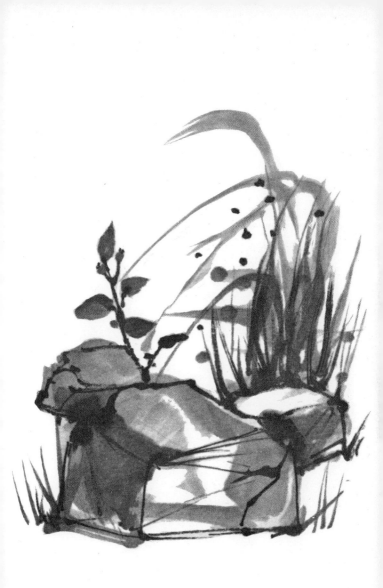